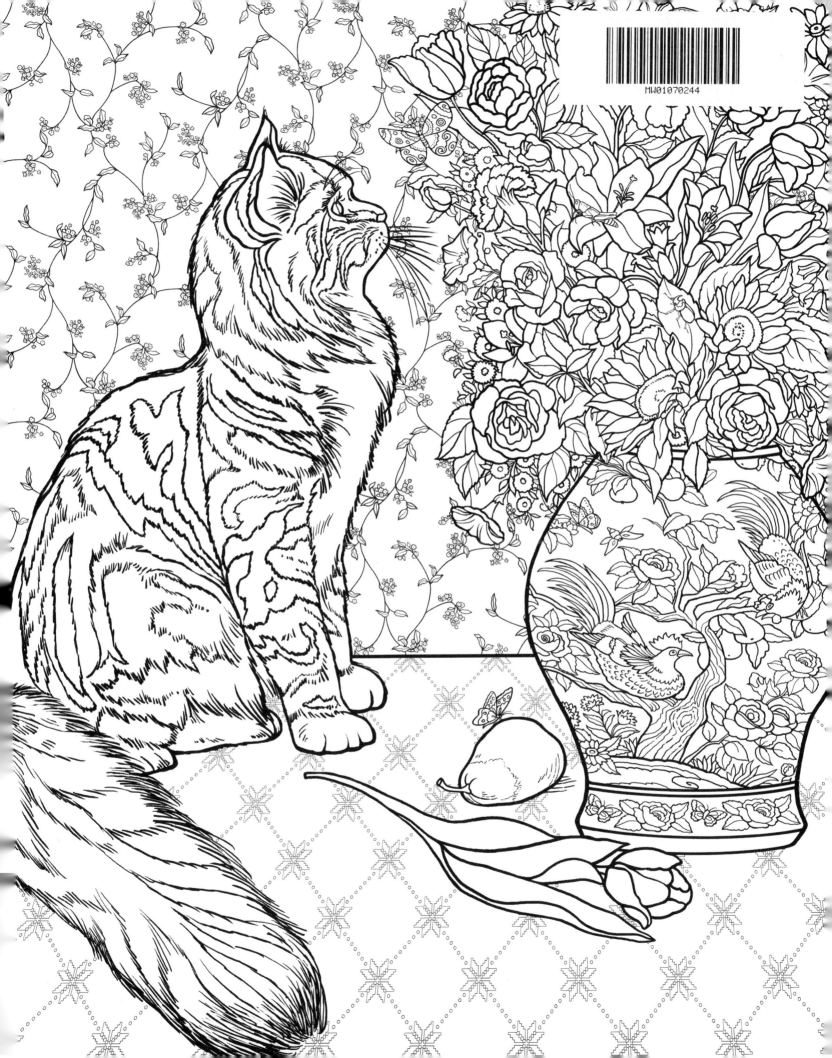

The smallest feline is a masterpiece.

Leonardo da Vinci

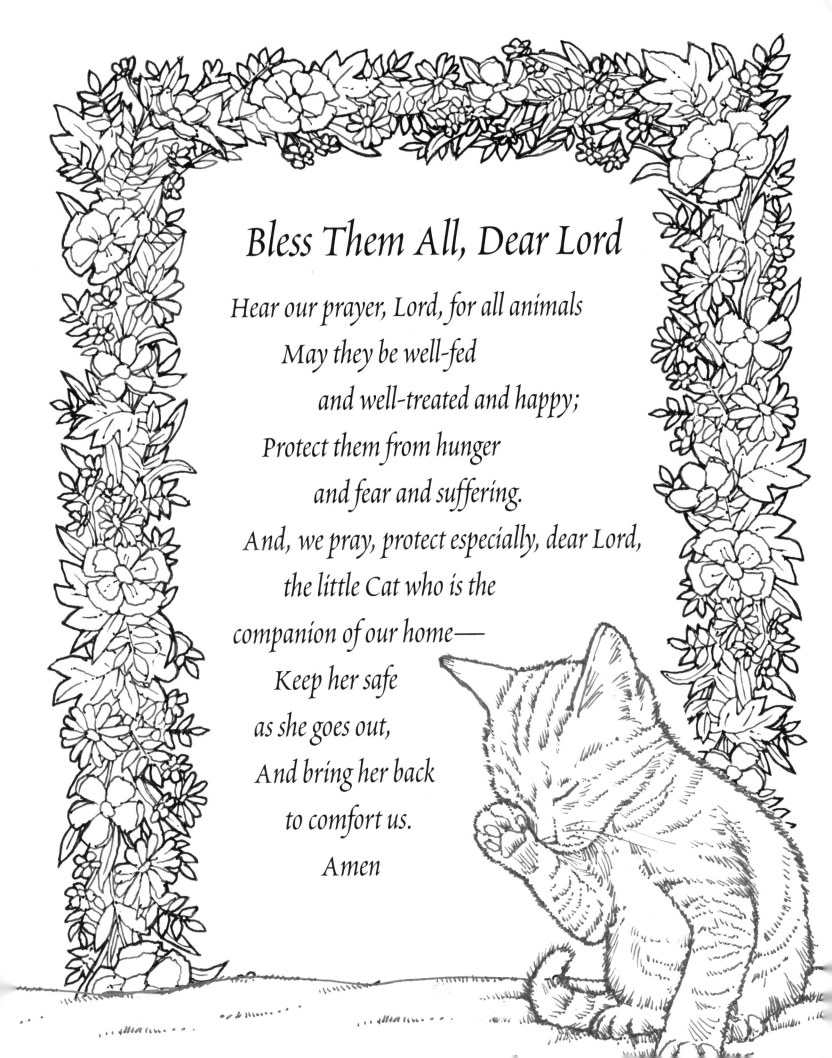

Bless Them All, Dear Lord

Hear our prayer, Lord, for all animals
May they be well-fed
 and well-treated and happy;
Protect them from hunger
 and fear and suffering.
And, we pray, protect especially, dear Lord,
 the little Cat who is the
companion of our home—
 Keep her safe
 as she goes out,
 And bring her back
 to comfort us.
 Amen

Bless Them All, Dear Lord

Hear our prayer, Lord, for all animals...

Created By: _____

Date: _____

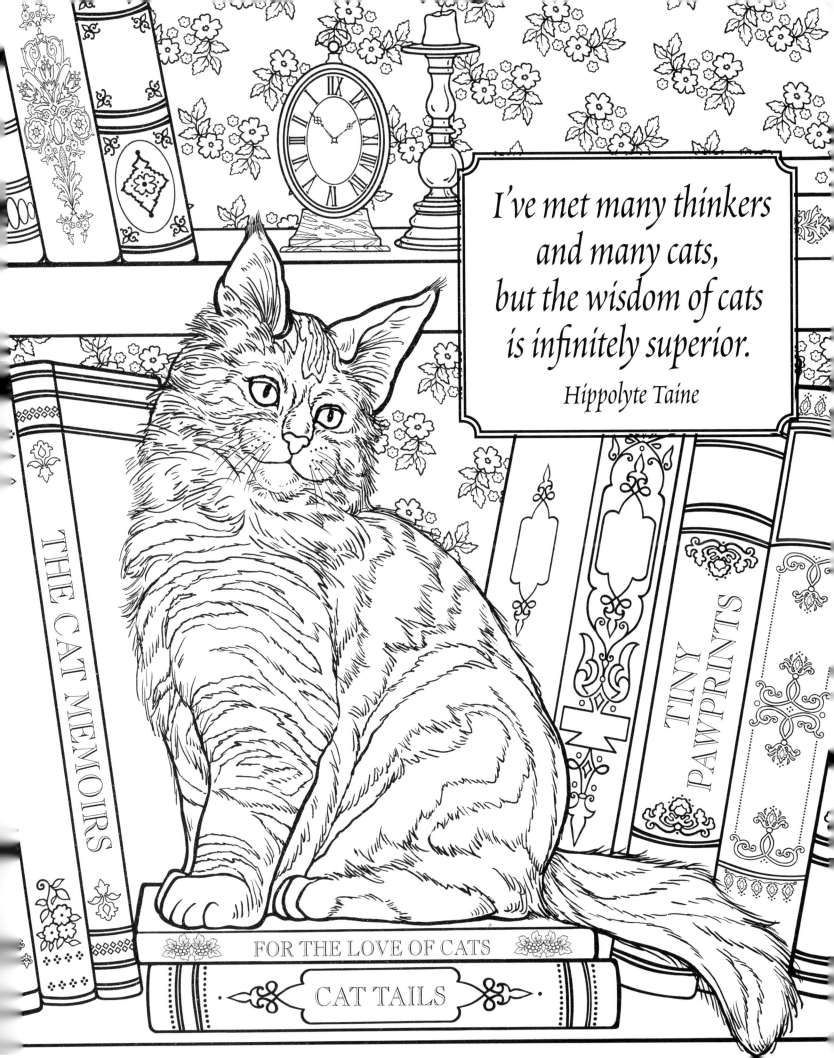

*I've met many thinkers
and many cats,
but the wisdom of cats
is infinitely superior.*

Hippolyte Taine

THE CAT MEMOIRS

TINY PAWPRINTS

FOR THE LOVE OF CATS

CAT TAILS

I've met many thinkers
and many cats,
but the wisdom of cats
is infinitely superior.

Hippolyte Taine

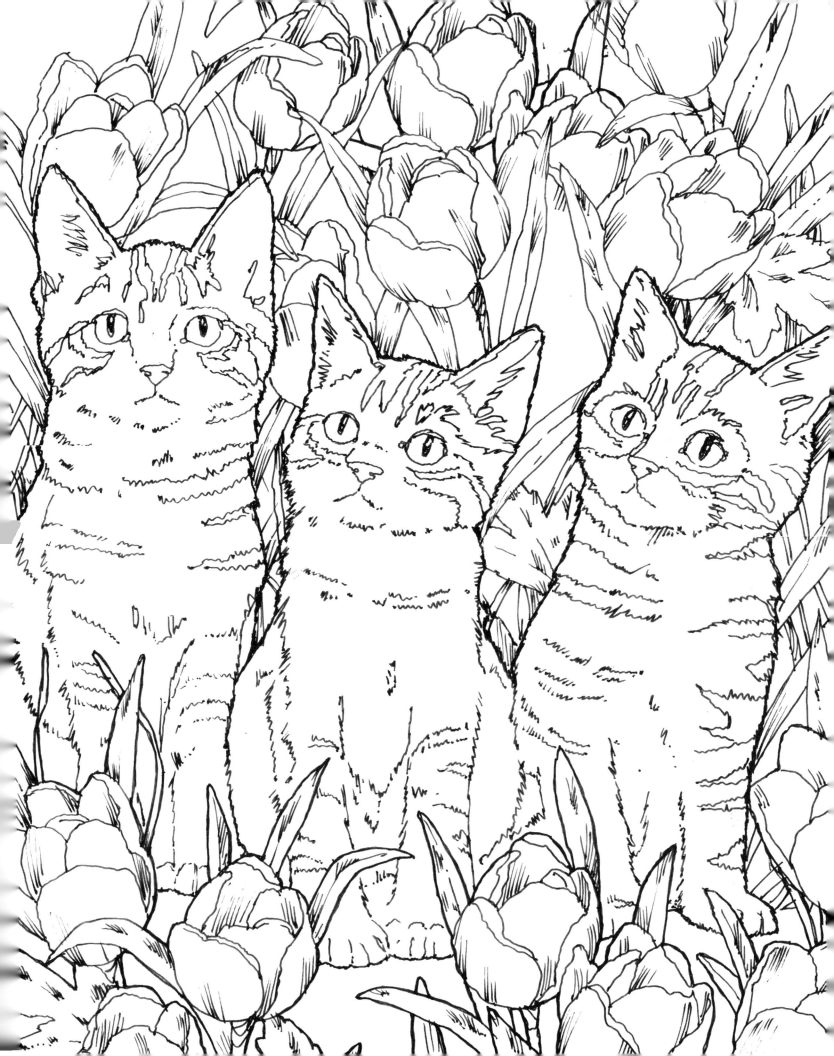

Animals are such agreeable friends -
they ask no questions;
they pass no criticisms.

George Eliot

Created By: _____

Date: _____

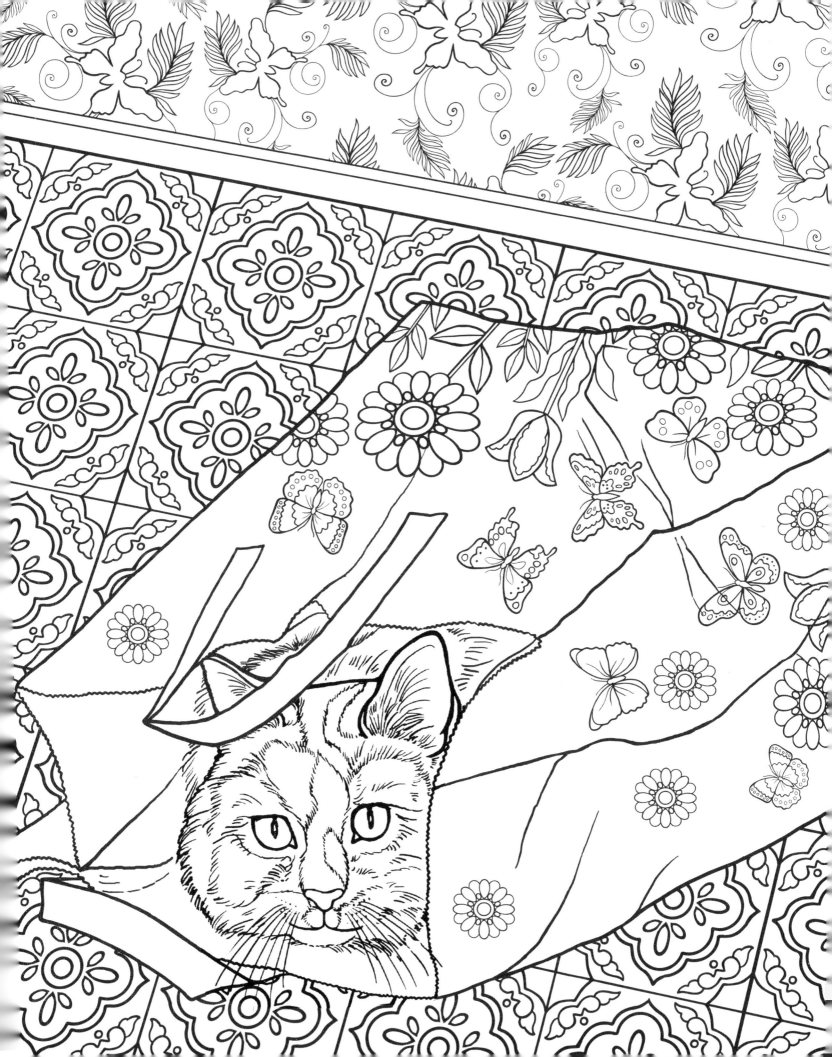

A kitten is the delight of a household.
All day long a comedy is played
by this incomparable actor.

Champfleury

Created By: _____

Date: _____

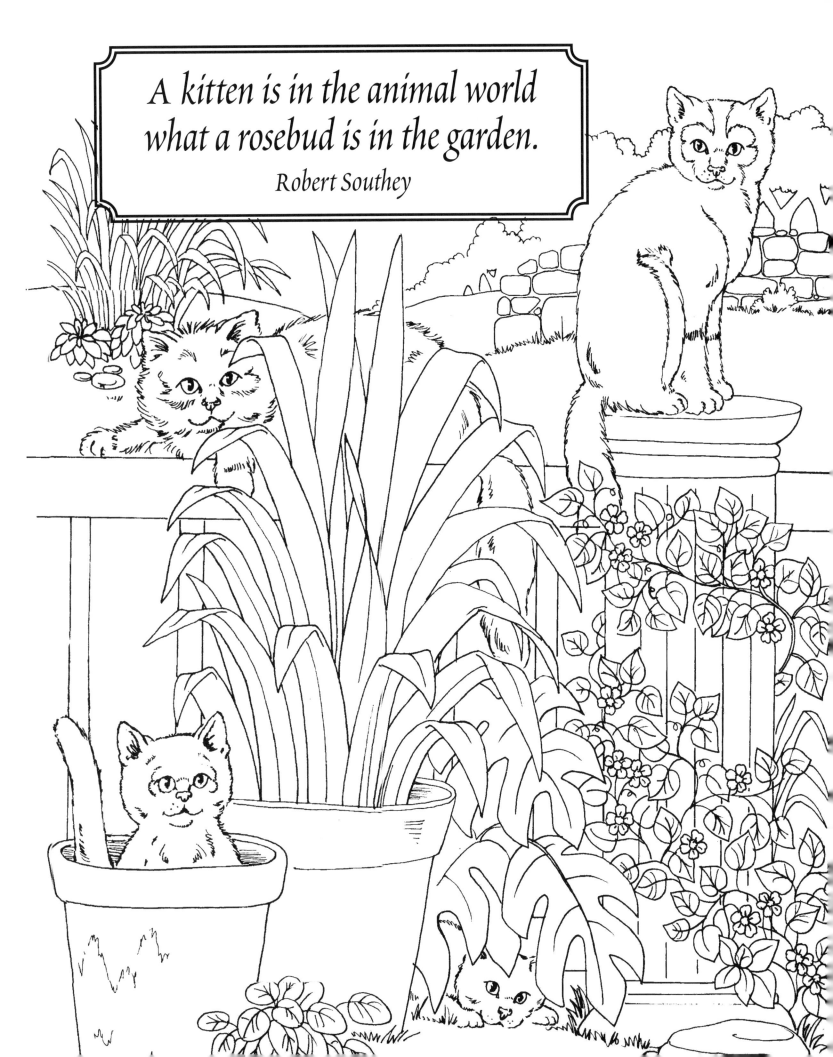

A kitten is in the animal world what a rosebud is in the garden.

Robert Southey

A kitten is in the animal world
what a rosebud is in the garden.
Robert Southey

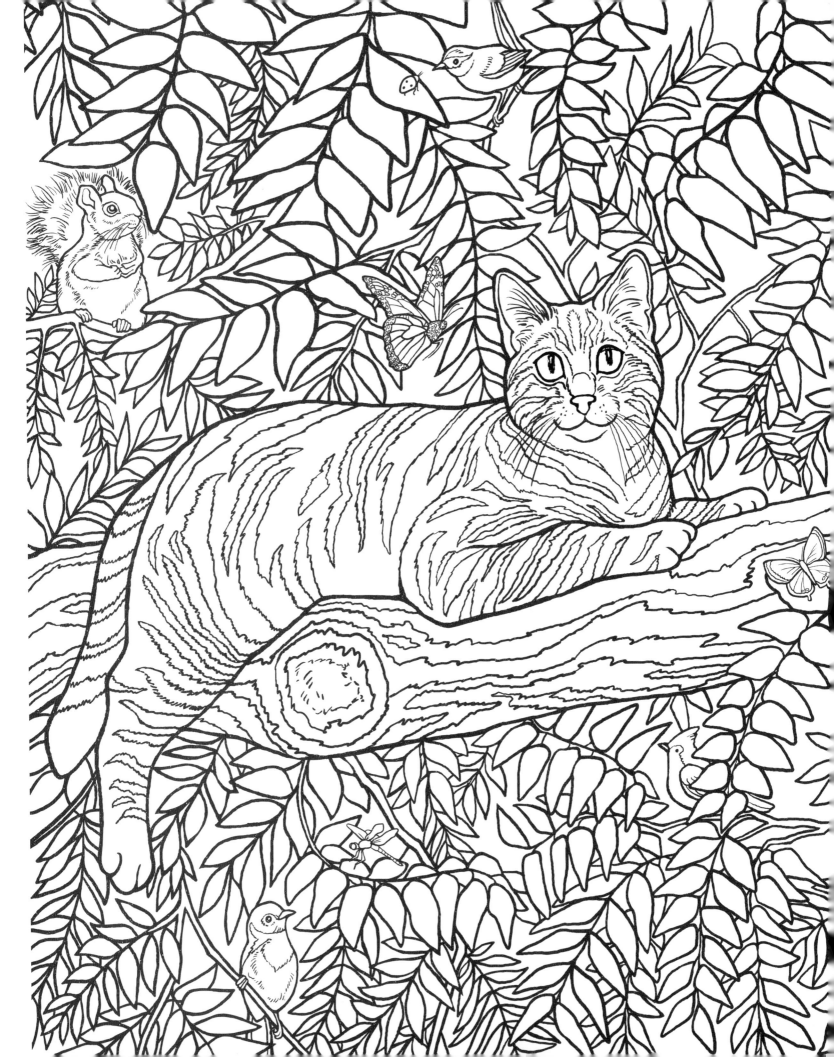

*All of the animals except for man
know that the principle business
of life is to enjoy it.*

Samuel Butler

Created By: _____

Date: _____

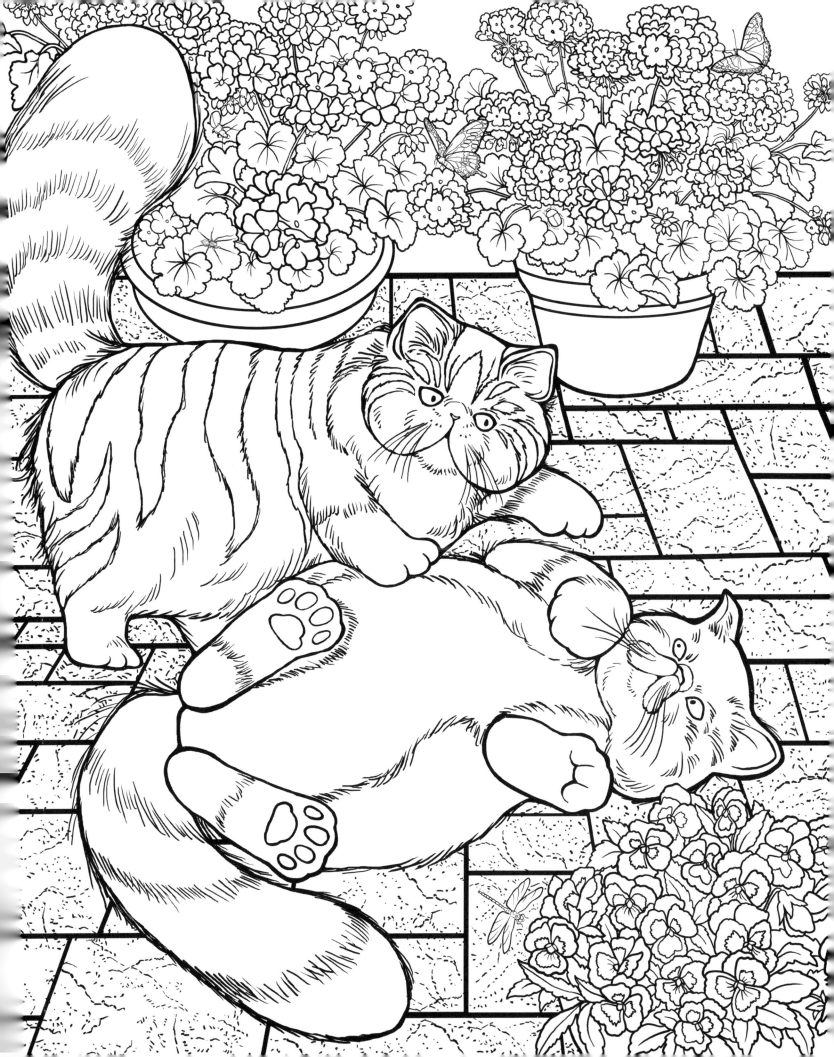

Mix a little foolishness
with your serious plans:
it's lovely to be silly at the right moment.

Horace

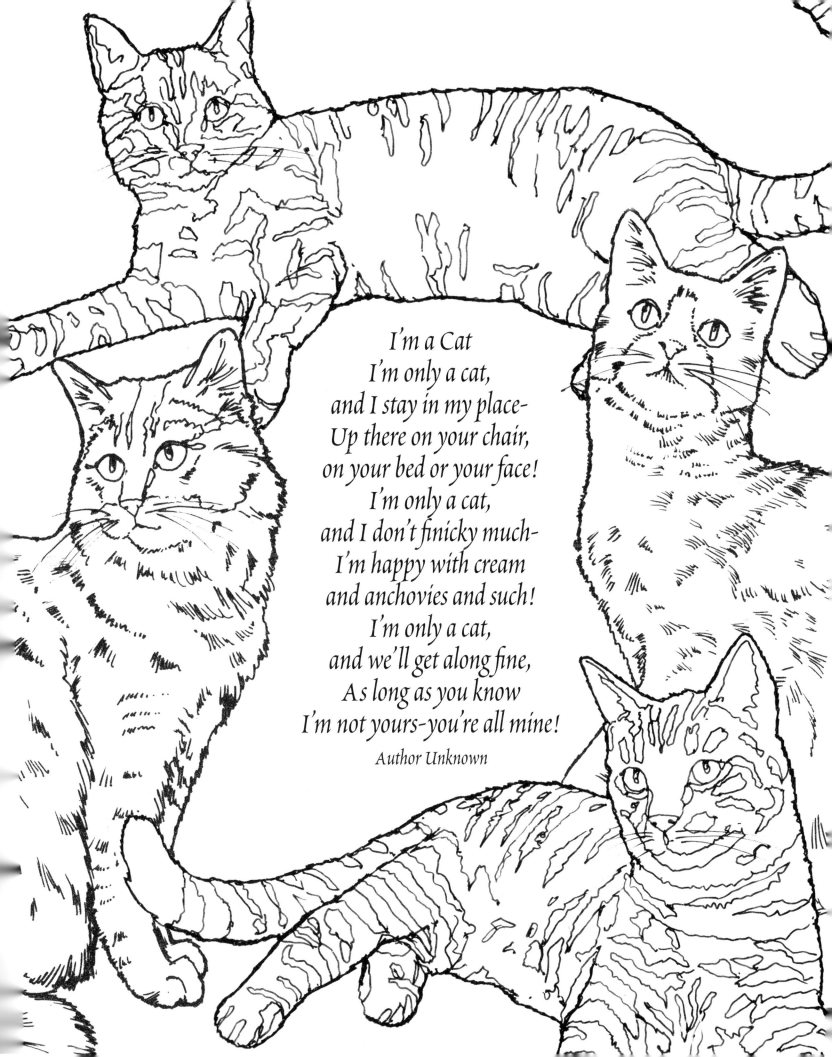

I'm a Cat
I'm only a cat,
and I stay in my place-
Up there on your chair,
on your bed or your face!
I'm only a cat,
and I don't finicky much-
I'm happy with cream
and anchovies and such!
I'm only a cat,
and we'll get along fine,
As long as you know
I'm not yours-you're all mine!

Author Unknown

I'm a Cat
I'm only a cat,
and I stay in my place...

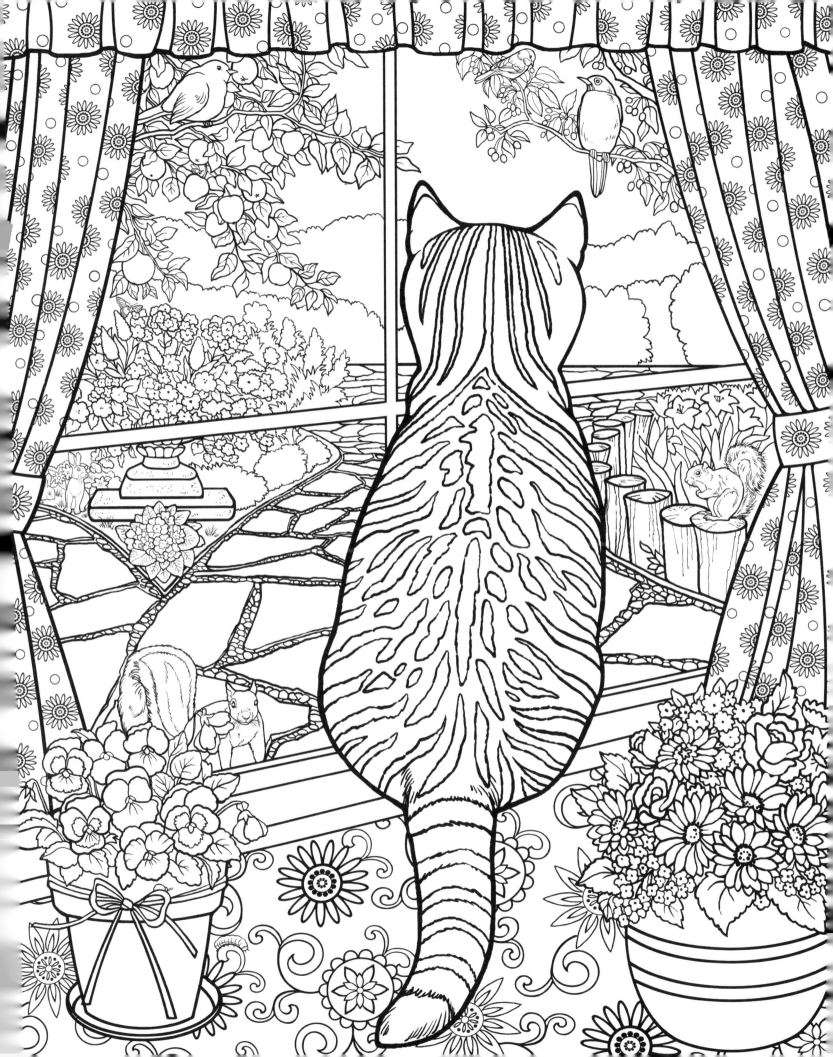

The idea of calm exists
in a sitting cat.

Jules Renard

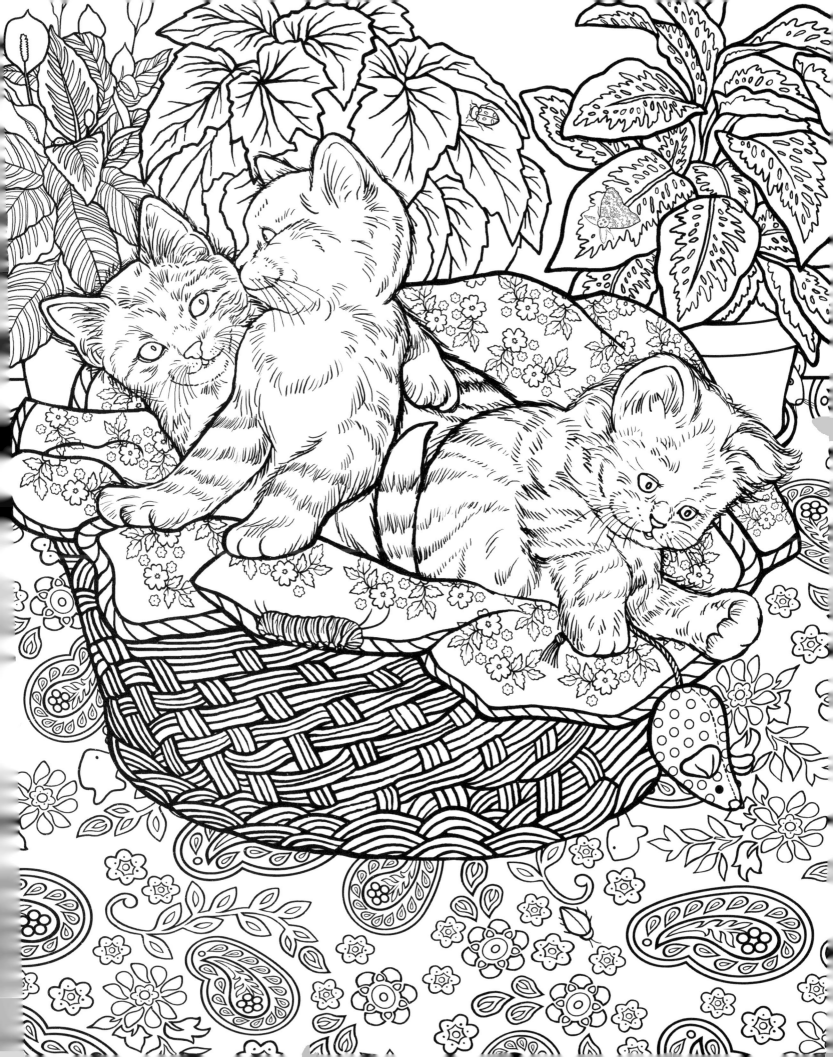

A kitten is chiefly remarkable for rushing
about like mad at nothing whatever,
and generally stopping before it gets there.

Agnes Repplier

Created By: _____

Date: _____

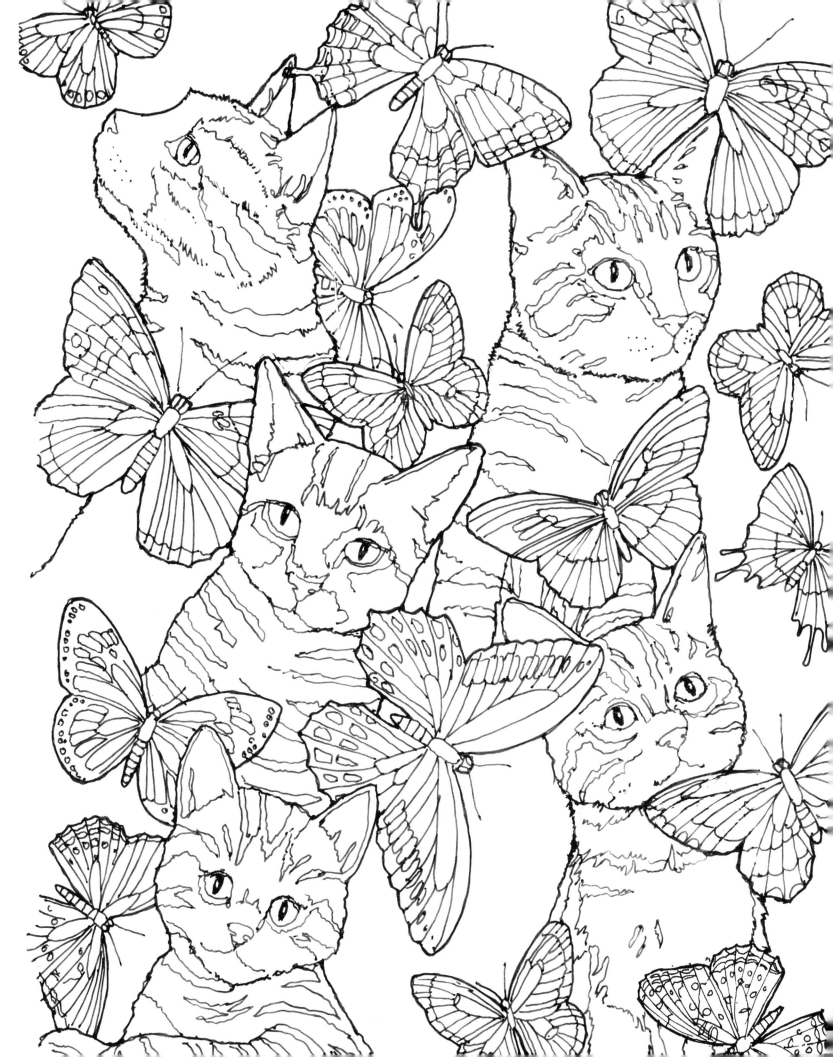

There are no ordinary cats.
Colette

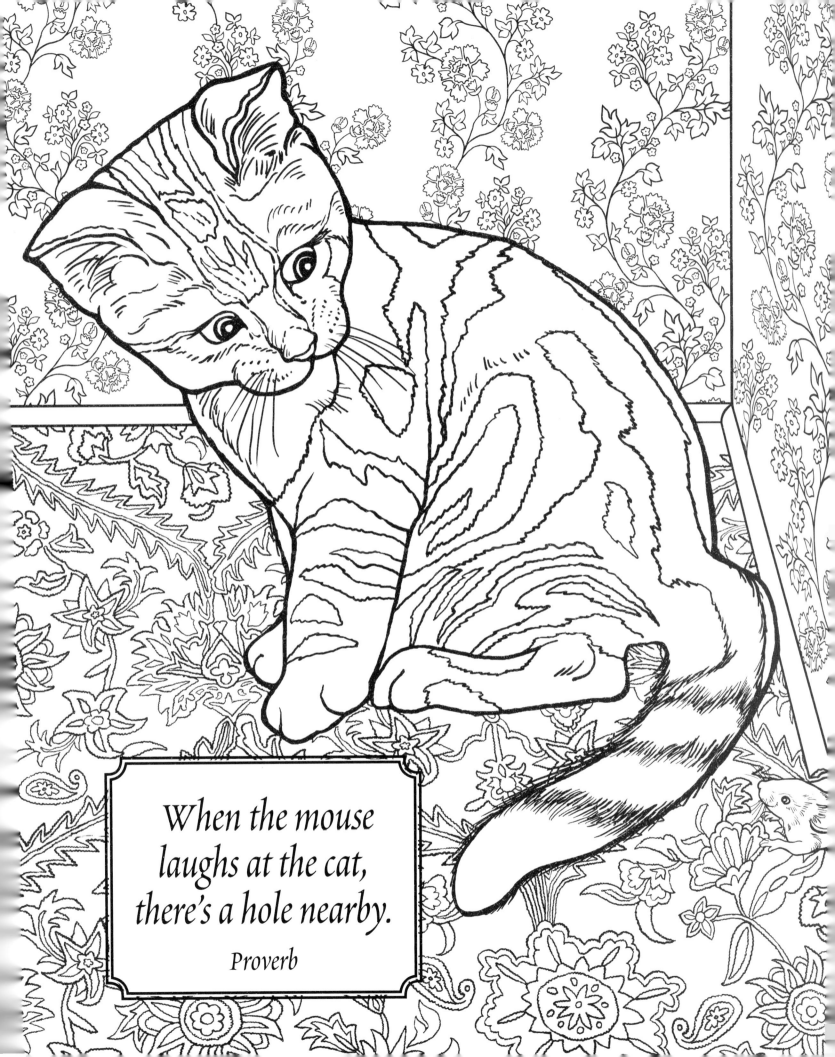

When the mouse
laughs at the cat,
there's a hole nearby.

Proverb

When the mouse
laughs at the cat,
there's a hole nearby.

Proverb

Created By: _____

Date: _____

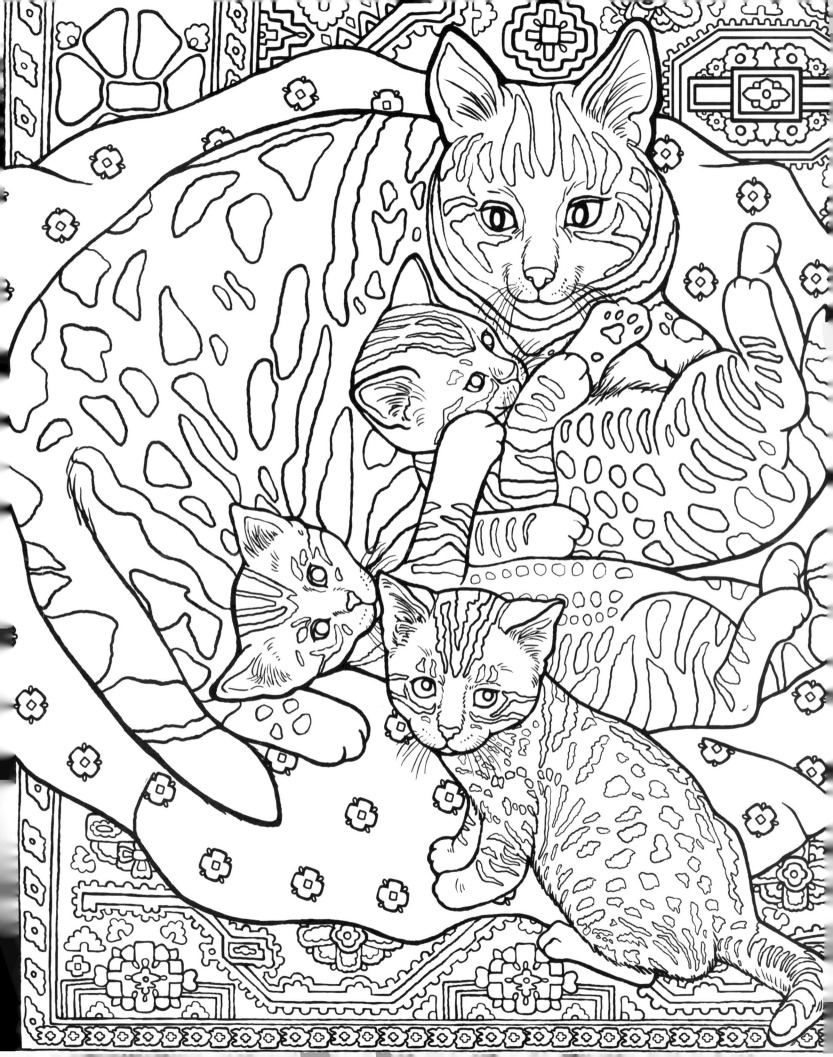

A well-spent day brings happy sleep.
Leonardo da Vinci

Created By: _____
Date: _____

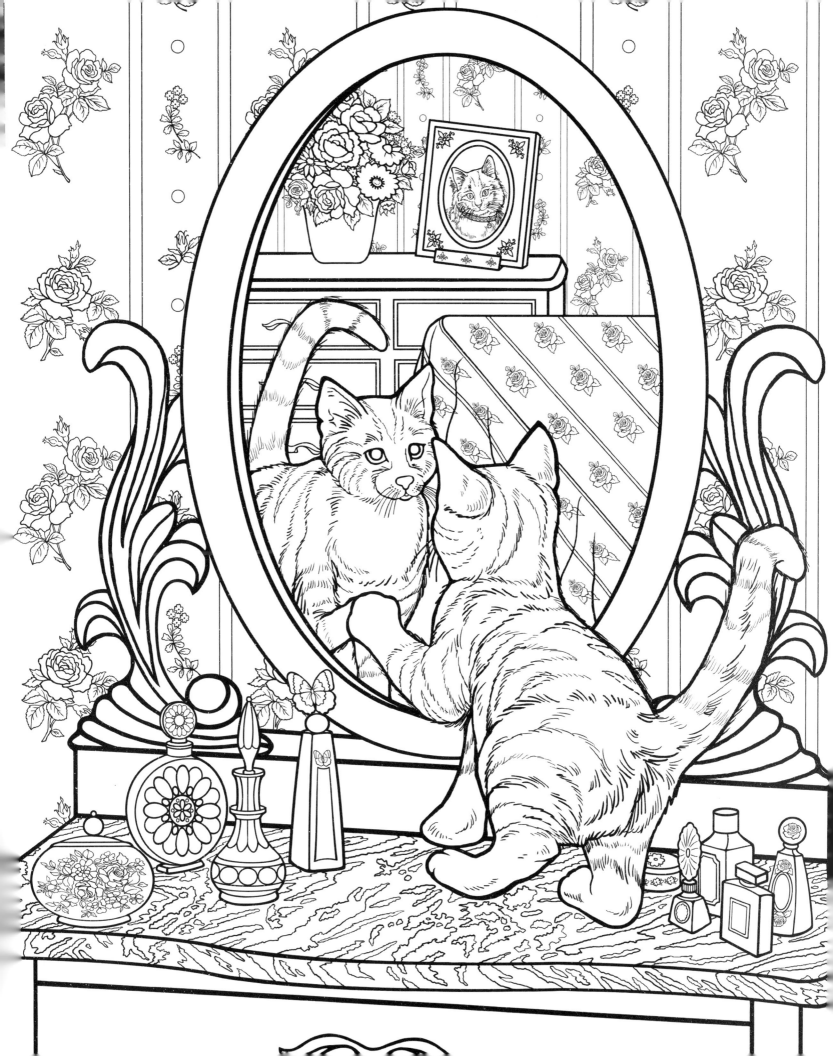

*To know yourself is at the heart
of wisdom.*

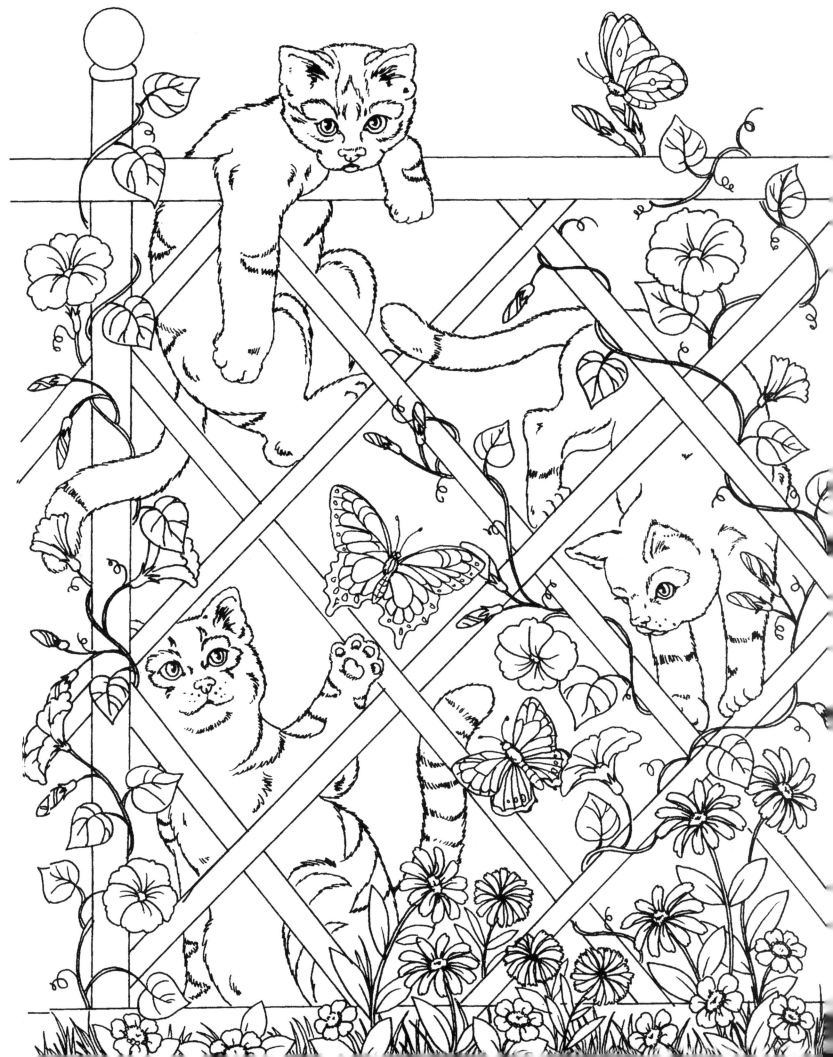

*There is no more intrepid
explorer than a kitten.*

Jules Champfleury

Created By: _____

Date: _____

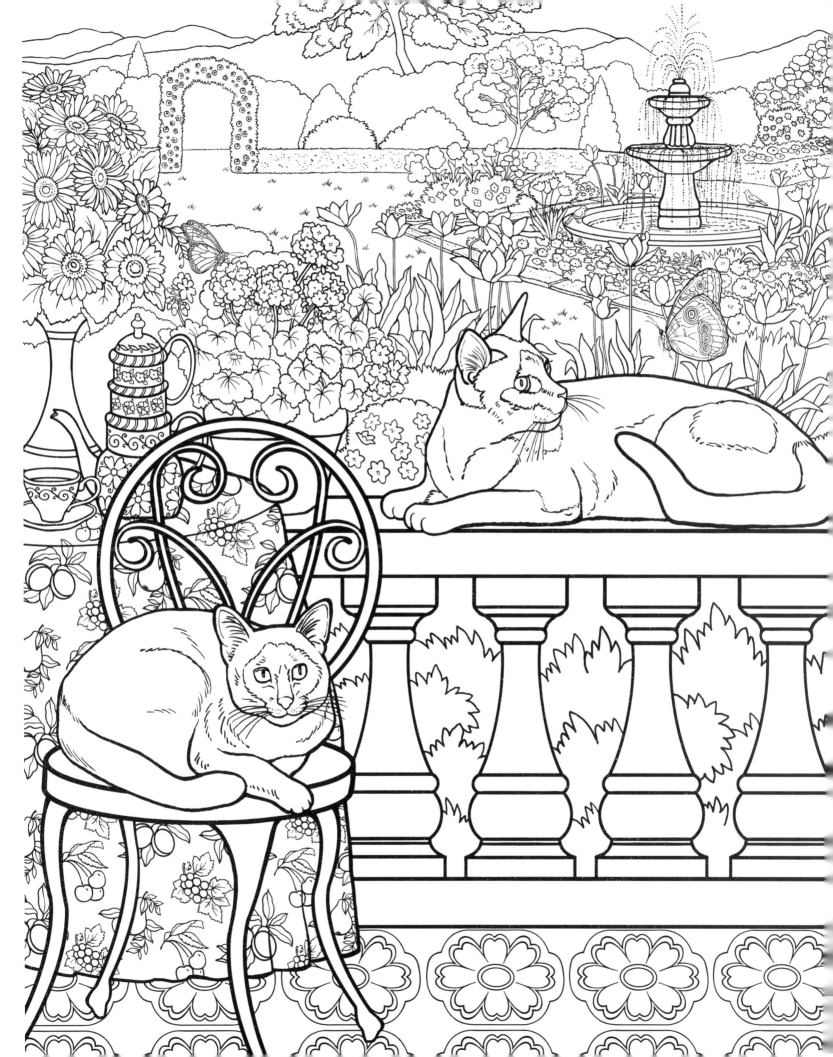

*Always I have a chair for you in
the smallest parlor in the world, to wit, my heart.*

Emily Dickenson

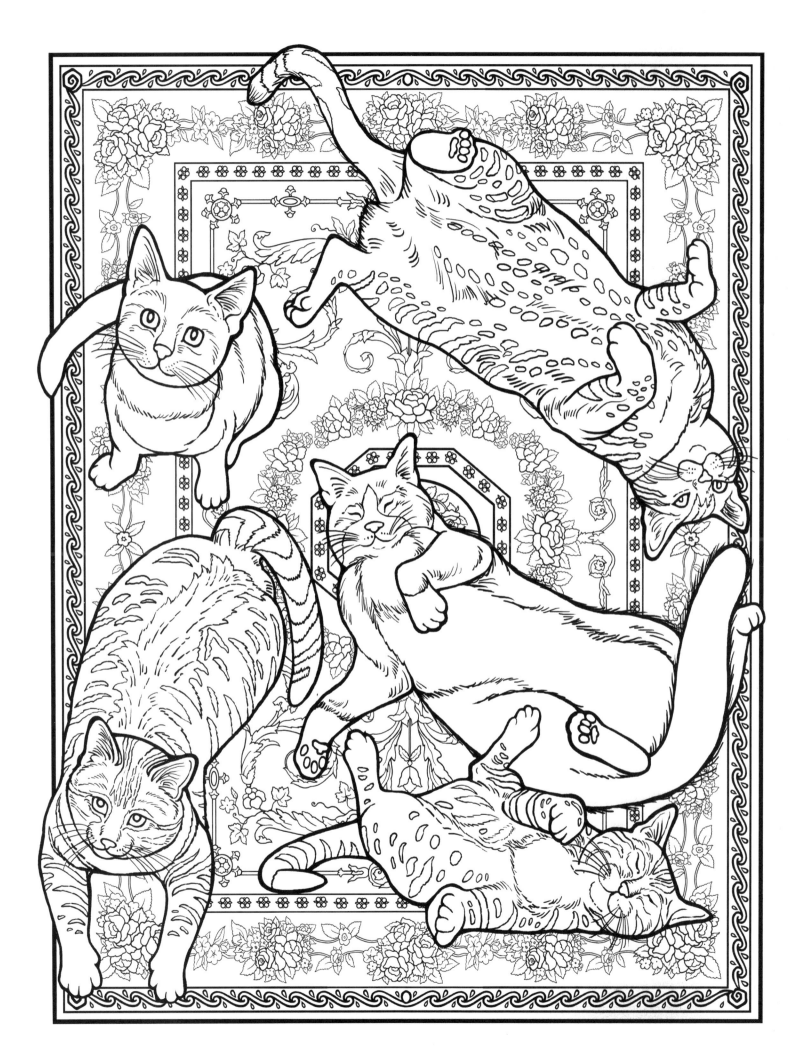

A cat pours his body on the floor like water.
It is restful just to see him.

William Lyon Phelps

Created By: _____

Date: _____

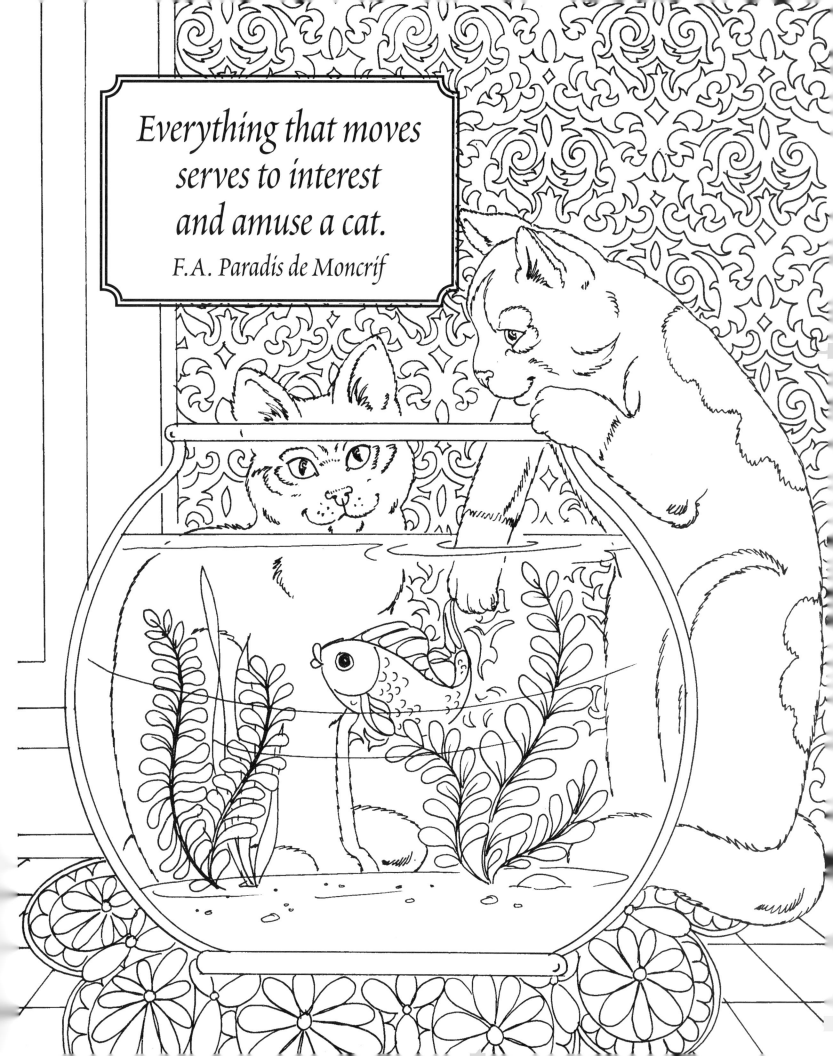

Everything that moves
serves to interest
and amuse a cat.

F.A. Paradis de Moncrif

Everything that moves
serves to interest
and amuse a cat.
F.A. Paradis de Moncrif

Created By: _____
Date: _____

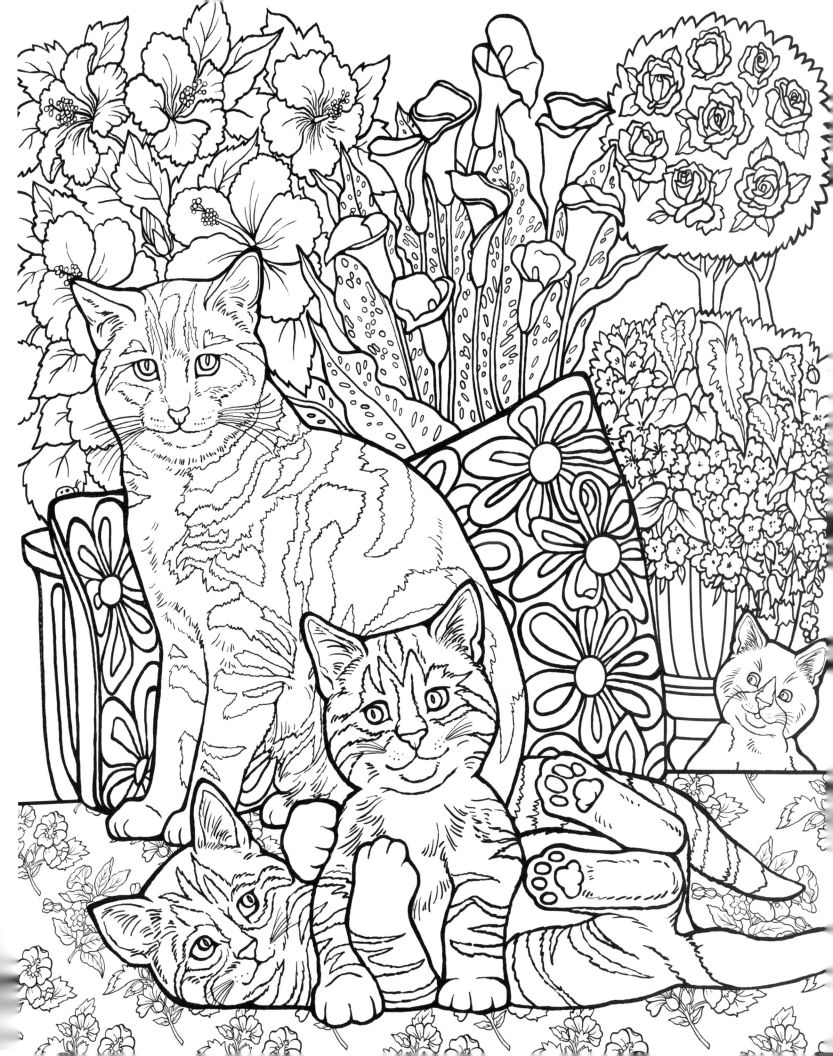

Happy is the home with at least one cat.

Created By: _____

Date: _____

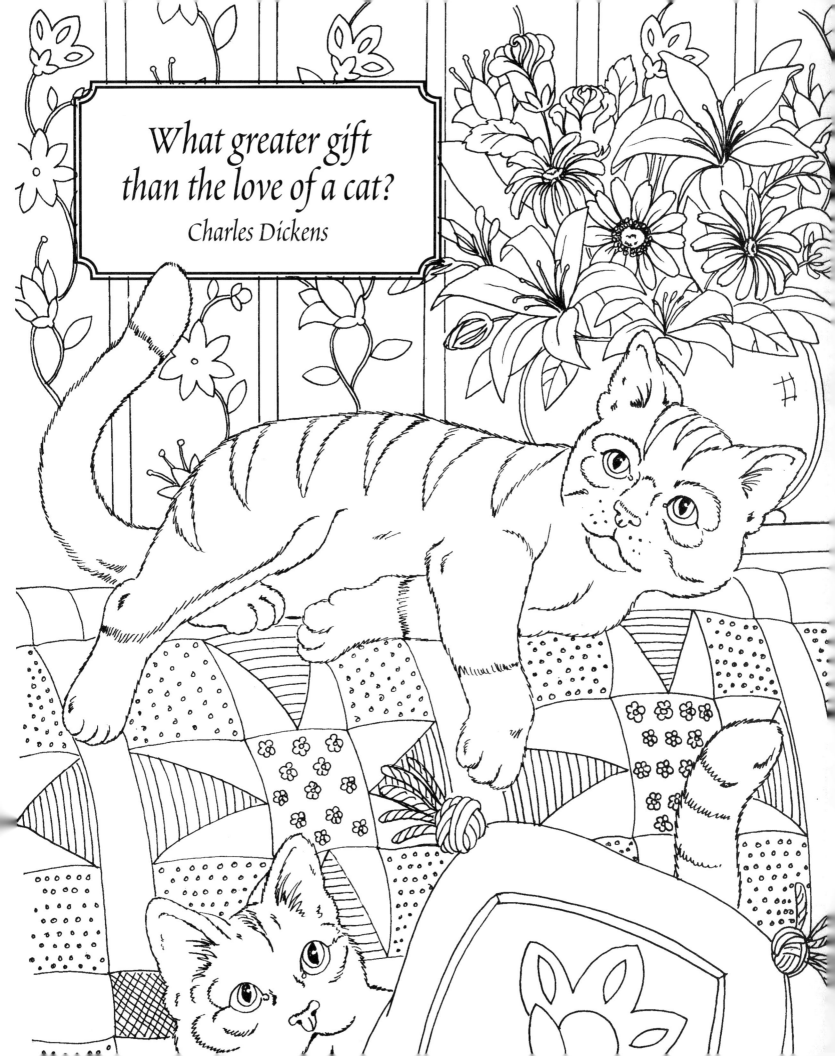

What greater gift
than the love of a cat?

Charles Dickens

What greater gift
than the love of a cat?
Charles Dickens

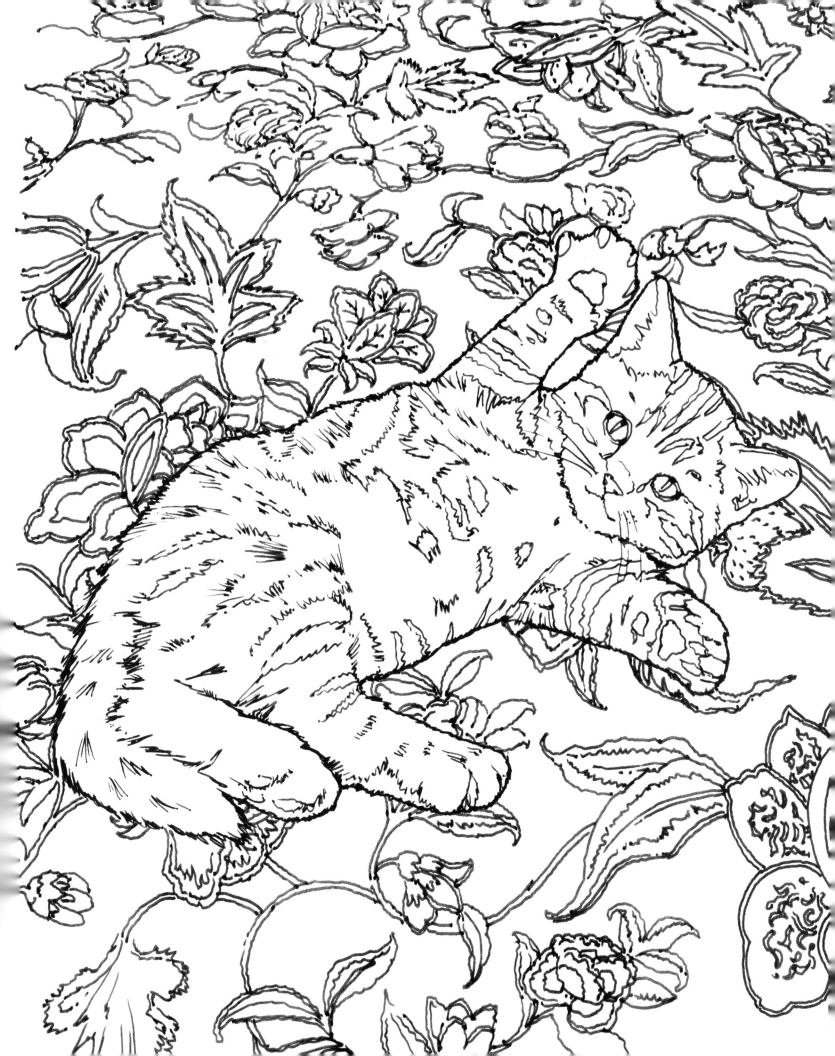

I've got a big hug with your name on it.

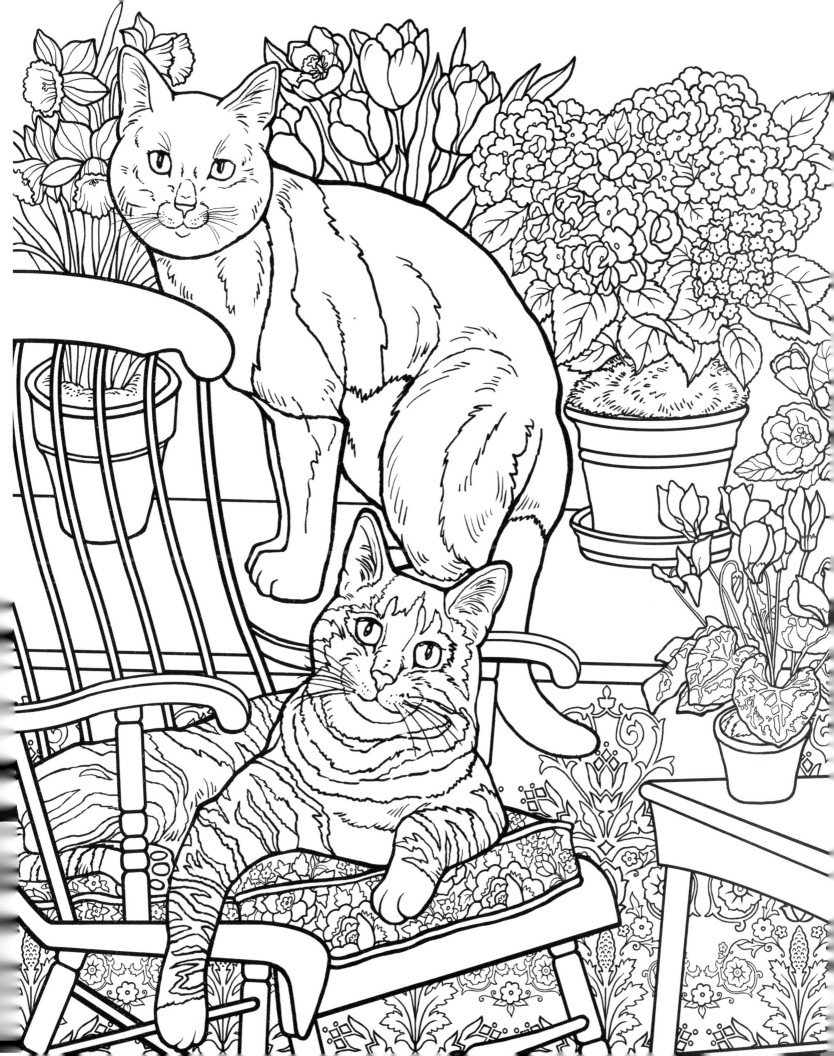

No heaven will not ever be;
unless my cats are there to welcome me.

Proverb

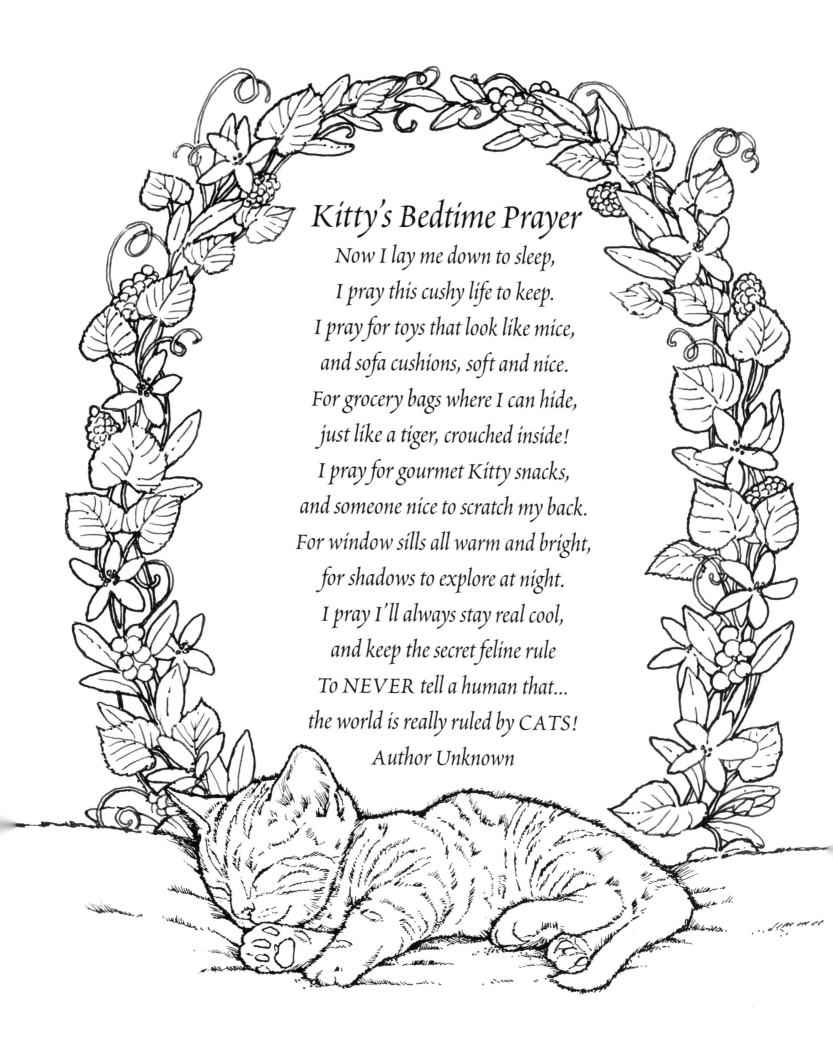

Kitty's Bedtime Prayer

Now I lay me down to sleep,
I pray this cushy life to keep.
I pray for toys that look like mice,
and sofa cushions, soft and nice.
For grocery bags where I can hide,
just like a tiger, crouched inside!
I pray for gourmet Kitty snacks,
and someone nice to scratch my back.
For window sills all warm and bright,
for shadows to explore at night.
I pray I'll always stay real cool,
and keep the secret feline rule
To NEVER tell a human that...
the world is really ruled by CATS!

Author Unknown

Kitty's Bedtime Prayer

Now I lay me down to sleep...

Created By: _____

Date: _____